LOVE

IN THE LOUVRE

MUSÉE DU LOUVRE

Henri Loyrette
President-Director

Didier Selles
Chief Executive Director

Catherine Sueur
Deputy Executive Director

Christophe Monin
Direction of Cultural Development

PUBLICATIONS

Musée du Louvre

Violaine Bouvet-Lanselle
Director of Cultural Development
Head of Publications

Fanny Meurisse
Editorial Coordination and Photo Research

Flammarion

Sophy Thompson
Director, Illustrated Books

Translated from the French
by David Radzinowicz
Design: Isabelle Ducat
Copyediting: Lindsay Porter
Typesetting: Gravemaker+Scott
Proofreading: Anne Korkeakivi
Color Separation: Reproscan, Italy
Printed in Malaysia by Tien Wah Press

AUTHORS

Jean-Claude Bologne is a historian and professor of medieval iconography at ICART in Paris. He has published over twenty works of fiction, dictionaries, and non-fiction and was awarded the Prix Théroigne of the Académie Française for *Histoire de la Pudeur* (Olivier Orban, 1986).

Elisa de Halleux has a doctorate in Art History and is the author of *Iconographie de la Renaissance* (Flammarion, 2006). She lectures frequently in France and the United Kingdom.

Editor's Note: All measurements of the works are given in height by width unless otherwise indicated.

Distributed in North America by Rizzoli International Publications, Inc.

Simultaneously published in French as *Amour*
© Musée du Louvre, Paris, 2008
© Flammarion SA, Paris, 2008

English-language edition
© Musée du Louvre, Paris, 2008
© Flammarion SA, Paris, 2008

08 09 10 3 2 1

Dépôt legal: 10/2008

Louvre ISBN: 978-2-35031-195-1
Flammarion ISBN: 978-2-0803-0077-5

www.louvre.fr
www.editions.flammarion.com

LOVE
IN THE LOUVRE

JEAN-CLAUDE BOLOGNE
ELISA DE HALLEUX

MUSÉE DU LOUVRE ÉDITIONS | Flammarion

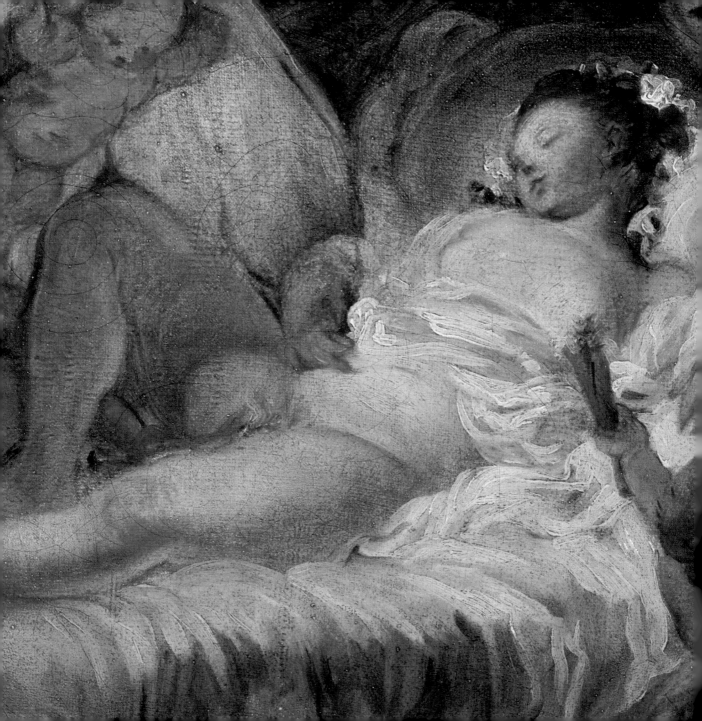

MUCH LOVE, MANY LOVES…
by Jean-Claude Bologne

Humankind has been celebrating love since there have been words to say it and arts to show it. But what kind of love are we talking about? The very human desires of Egyptian poetry—which already compares love to a disease, the conjugal romance of Akhenaton and Nefertiti, or the transcendent power that overcomes the tragic heroine Phaedra?

Images cannot be as precise as texts and even the latter can be ambiguous, and so the temptation persists to read both in the light of present-day conceptions that advocate the (impossible) fusion between passion and wedlock, between unbridled sexuality and reassuring tenderness. In former times, in order to experience love in these various manifestations, a man would have taken three or even four companions: wife, mistress, and courtesan were kept separate, since to require one to fulfill the role of any other would be tantamount to disrespecting both. Rubens might immortalize Henry IV in adoration of Marie de'Medici but even as the sovereign was receiving the portrait of his future queen, he was the lover of Henriette d'Entragues.

First and foremost, the works in this volume should be seen as an invitation to change our opinion of what constitutes love. What is real and what is fantasy in an erotic scene from Greek antiquity? How much is the conjugal harmony between a royal couple simply propaganda? What role do the conventions, even clichés, of art play in tomb statuary?

JEAN-HONORÉ FRAGONARD
(1732–1806)
Le Feu aux poudres, also known as *The Powder Keg,* c. 1763–1764 (detail)

A comparison between the visual and literary arts already arouses suspicion: for the most part, painting, sculpture, and the miniature depict the happier, more fulfilled side of love, while poetry, theater, and the novel privilege the star-crossed. When a picture does refer to the ordeals of love, it is almost always in reference to some preexistent storyline: without literary references, how can one understand Bathsheba's sadness, Echo's tragic demise, or Paolo and Francesca's horrid punishment?

The arts of the past needed some kind of narrative drive, and so they multiplied obstacles to be overcome and sufferings to be endured: the fable of Psyche would have quickly fizzled out had she not been banished from Cupid's palace. Happy love is not often the subject of poesy—except when it generates an exaltation that transcends human emotion and elevates man to the sphere of the divine. Suffering or bliss: these two currents are already to be seen flowing through the literature of antiquity. Primarily they concern the unmarried—young people in search of a soul mate, adulterous couples, same-sex partners, and so on.

The visual arts, on the other hand, are more amenable to demonstrations of tenderness, to caresses and kisses, which capture a moment of joy without necessarily retelling the entire story. For this reason, and from the earliest times, they offer edifying examples of marital affection, the most moving occurring in funerary art where steles and sarcophagi offer lasting proof of married bliss. Historians are right: although love is not incompatible with marriage, in the majority of cultures and up to very recent times, it does not precede it. The handful of counterexamples aroused mistrust or reproof: Jacob had to marry Leah before being united with his true love Rachel; Pericles abased himself by making an honest woman of Aspasia, who would have made a fine mistress but was an unworthy wife. We thus encounter a different form of love, represented as more compatible with the dignity of holy matrimony.

It is "a sort of incest," Montaigne opined, "to expend in this venerable and sacred union [marriage] the exertions and extravagances of licentious love." The whirlwind romances of literature can only disrupt a matrimonial politics founded on the stable alliance between two families and the balancing of wealth or power. And even if, by some extraordinary chance, passion does reign in the matrimonial household, it was considered polite to hide it under a bushel: the Prince of Clèves, in the 1678 novel by Madame de La Fayette, conceals from his wife the passion he feels until his death, "afraid of displeasing you or losing something of your regard through behavior unbecoming in a husband."

On the other hand, a loving friendship may spring from matrimony, be it peaceful marital companionship or, in the Christian tradition, as the result of the charitable

grace that descends upon the spouses at the blessing. Though a political union, the marriage of Julius Caesar's daughter Julia to Pompey blossomed into a love match, while Saint-Simon, who confessed to originally marrying his father-in-law rather than his wife, proved an inconsolable widower. It is the love arising from wedlock that artists represent rather than the passion that leads up to it. An artist might paint Isaac's heartfelt affection, but one shouldn't forget that it was his father who gave him Rebecca and that she had been chosen by the servant, Eliezer.

Tragic, all-consuming passion or marital tenderness: in stories and representations these two forms of love are kept neatly distinct. This separation chimes in with philosophical ideas that clearly distinguished love from marriage and exerted a considerable influence on artistic practice. For two millennia, Europe continued to be more or less in step with Plato and contrasted celestial love (Uranian Eros) with a lower form (Pandemic Eros): the first generates ideas in the soul that it raises up to the contemplation of ideal beauty; the second generates children in the body and is realized in marriage. Deeply felt affection between the married was extolled by both Aristotle and Christian thought, being elevated from the twelfth century onwards into a form of charity (love) arising from the sacrament. At the same time, so-called courtly love, which infuses the knight with near mystical "joy," offers the most perfect form of extra-conjugal love, high-minded and unsullied. The incompatibility between these two forms was naturally skirted over.

In any case, both are strenuously differentiated from mere animal instinct or concupiscence, which is compared to a disease and treated medically. The courtly lover, who, on a famous tapestry, presents his heart to his lady, is not intending to become a prisoner of Venus, as was frequent in the art of the fifteenth century. A husband who cannot control his sensuality with his wife is almost an adulterer; so thought Seneca, echoed by St. Jerome and nearly every Christian moralist. Marital or not, love is proven by respect for one's companion—and, thus, by reining in desire. The Renaissance was to become exceedingly fond of binary allegories, opposing Eros and Anteros, love and chastity, worldly love and celestial love.

There are thus not two, but at least three distinct types of depiction that, according to period and/or media, are more or less dignified or stigmatized: wedlock, amorous passion, and (extra-conjugal) concupiscence. And this does not take into account a whole raft of further alternatives: homosexuality, heroic *furia*, prostitution, Cartesian love, and the thousand, and, one gradations of gallantry, preciosity, and flirting. The works in this volume remind us of the range: a ruddy-faced soldier in Gerard ter Borch's painting here dangles a solid coin, while Watteau's gallant makes the most of a girl's *faux*

pas (literally, false step)—surely they cannot have the same kind of love in mind. A painting by Toussaint Dubreuil shows both Orlando and Medoro before Angelica, but one is mad with rage and the other overcome by tenderness.

However, if word and image reflect similar attitudes, their means are necessarily quite different. By their very nature, the visual arts privilege the physical component of love. Bodies can be represented, while feelings can only appear allegorically (the gift of a heart) or through signs of affection (two hearts carved on a tree). Nudity benefited from a tacit agreement that permits a modest dose of the sensual. Except in patently erotic art, for reasons of decency, the sex act—easier to infer in literature—is not portrayed. Painters evoke sex with more or less blatant metaphors: a bolt shot shut, money changing hands, a broken jug, or Fragonard's torch setting the senses ablaze. Antique, medieval, and classic modern literature privileges, on the other hand, the union of the soul, pure love, or at least that justified by a licit union. If the body yields, it is because the passion is too strong, and in this case—and especially from the nineteenth century on—sex may be decently referred to without the work being relegated to the "top shelf."

Love in the visual arts can thus appear relatively limited: often confined to an embrace, a kiss, or a mere glance, it can be reduced to an inviting gesture, as in Gainsborough's *Conversation in a Park*. If there is no literary source, it is not always possible to determine whether the feeling corresponds to the act, whether the couple is married or just contemplating wedlock, or whether their physical proximity constitutes a prelude to sexual union or amounts instead to the limit of their relationship. Did the spouses the painter brings together really adore one another? Did they marry for love or has their affection grown from their living together? Who can possibly say for sure? Such details cannot be deduced readily from an image. The context may offer some compensation: a given scene on a marriage trunk, in a town hall, or in a bridal chamber, even if relatively earthy, does not have the same meaning as it would in a Pompeii brothel. But in general the scene has to be clarified by literary references. The bonds between the graphic arts and literature are seldom as close as in representations of love that frequently allude to mythology, the Bible, courtly love, or the chivalrous novels and epics of the sixteenth century. How many visitors to the Louvre have read their Ariosto (*Medoro and Angelica*) or their Tasso (*Rinaldo and Armida*)?

Yet images dispose of their own internal codes and references. In the courtly love tradition, the knight who attacks the Castle of Love and is at last crowned by his lady at the top of the ladder might be said to evoke the soul's reward when it is crowned by the hand of God at the summit of the ladder of virtue. *Fin'amor* (fine love) often shadowed

religion, and the ecstasy experienced by the lover is as intense as the beatific vision of any mystic. A gallant with his lute symbolizes amorous harmony, while the bagpiper appeals to more down-to-earth pleasures. Nonetheless, a lover with a lute cannot have the same significance in a representation of the four temperaments (where he embodies phlegmatic love), as in a *Triumph of Death* (where he evokes ill-preparedness) by Bruegel or a *Ship of Fools* by Bosch.

Moreover, such ambiguity in interpretation hardly constitutes a weakness, since it allows the artist to manipulate his audience. Is Watteau's young man really helping up a girl who has "fallen" after a "faux pas"? A novelist would have to be specific, but a painter can let the viewer extrapolate the scene as he sees fit. Admitted by Ingres into the *Turkish Bath*, we are free to take up his languishing beauties in a sensual embrace or to conduct them through the open door to some concealed lover. We can only guess at whom Boucher's odalisque is gazing with a look one can interpret as either free-and-easy or mischievous—and just because on that particular day we might ourselves feel either mischievous or free-and-easy.

Deciphering these internal and external references or codes is even more interesting in a scene which, on first reading, seems as clear as day. For, believe it or not, nothing is more difficult to decode in a picture than a kiss. And this is far from coincidence, since love is a cultural entity, something learnt about through written and visual representations. The multiculturalism of our era demonstrates this amply enough; misunderstandings may be tragic and what, since Adam and Eve, should be the most beautiful thing in the world, still provides material for tittle-tattle and scandalous headlines.

Yes, love is something that can be taught, constructed, even transformed in the great melting pot of culture. And, through the chronicle here presented by works in the Louvre, we can discover anew all the ways that people have loved and have sought to convey this love.

SELECTED WORKS

Text by **Elisa de Halleux**

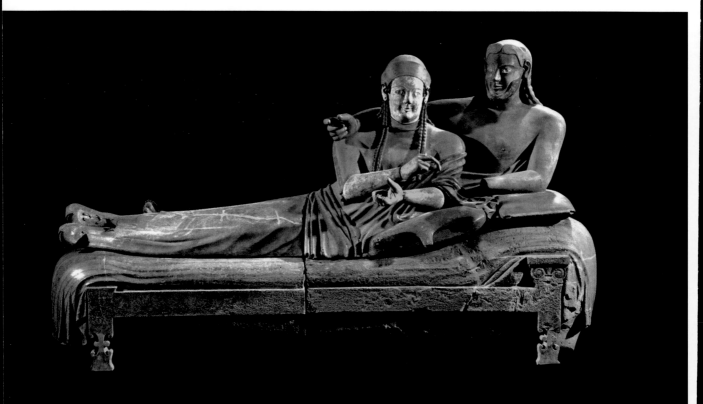

1. ANONYMOUS

Sarcophagus of the Cerveteri Couple
Cerveteri (Caere), Southern Etruria, c. 520–510 BCE
Polychrome terracotta, 3 ft. 7 ¾ in. × 6 ft. 6 ⅜ in. (1.11 × 1.94 m); d. 27 in. (69 cm)

2. ANONYMOUS

Akhenaton and Nefertiti
Middle Egypt? Tell el-Amarna?, New Empire, Eighteenth Dynasty,
reign of Amenophis IV Akhenaton, between 1345 and 1337 BCE
Sculpture in the round, polychrome limestone, 8 ¾ × 4 ¾ in. (22.2 × 12.3 cm);
d. 3 ⅞ in. (9.8 cm)

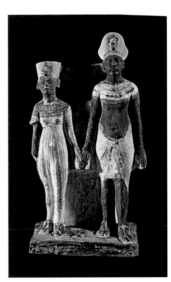

1. Semi-prone on the "bed" of the sarcophagus, the figures take up a pose characteristic of banqueters of the ancient world. Their tender gestures and serene smiles imply that they are a married couple, now united in death for all eternity. The habit of feasting half-lying down was adopted from Asia Minor. Whereas among the Greeks it was the preserve of men alone, among the Etruscans it extended to women as well, reflecting their significance in society. In the context of a funerary monument, the image of the reclining banquet probably has a dual significance.

Initially, it is meant as a sign of the wealth of the deceased's family, but it may also have a ritual meaning, referring to the wakes and feasts that would be held in honor of the dead. The woman is pouring scented oils onto her husband's palm, and both are seated on cushions in the form of a wine-skin. Offering perfume, like sharing wine, formed part of Etruscan obsequies. The monument thus testifies to the respect Etruscan society had for its forebearers and to the importance it attached to matrimony.

2. The royal couple is portrayed in a standing position, as if walking hand in hand. Their appearance—narrow shoulders, full hips, round stomach, and protruding torso—is characteristic of the reign of Amenophis IV, who took the name of Akhenaton in homage to the sun god, Aton, whom he venerated above all the others. The figures are fixed on a sizable stand, with an inscription that draws attention to the role the sovereigns played as manifestations of the divine on earth. Originally, this small sculpture was intended for a domestic shrine: according to the Amarna religion, the royal couple acted as an intercessor between the divine and its creation. It is in this context that the homely gestures of the couple are to be interpreted. The Eighteenth Dynasty was, it should be noted, one of the few periods when Egyptian art favored expression and humanity.

1. NICOLAS POUSSIN (1594–1665)
Eliezer and Rebecca, 1648
Oil on canvas, 3 ft. 10 ½ in. × 6 ft. 8 ⅜ in. (1.18 × 1.99 m)

2. NICOLÀ DI GABRIELE SBRAGA,
CALLED NICOLÀ DA URBINO (active 1520–1537/8)
Plate with the coat of arms of Isabella d'Este Gonzaga,
Marchesa of Mantua, Urbino, c. 1524
High-fired faience, d. 10 ½ in. (27 cm)

1. Rebecca—the young woman dressed in blue in the center of the picture—offers water to Eliezer, the servant Abraham has sent out to find a wife for his youngest son, Isaac. Rebecca even draws some for Eliezer's camels. Such generosity immediately convinces Abraham's servant: this is the woman designated by God to be Isaac's wife, and he hands her a gold ring in recognition of this. She accepts the grace bestowed on her with one arm across her chest in humility. In response to this important event, as related in Genesis (22:7), some were to express respect and joy and others astonishment mingled with jealousy. The painter captures each of these human reactions.

2. Here we see King Abimelech spying on Isaac and Rebecca from a window. The majestic and airy composition of this delicate majolica is borrowed from a fresco by Raphael's workshop in the Vatican Loggie. To express the intense love between the two young people, the artist shows their bodies intertwined and their faces held close together in a kiss. Rebecca has even wrapped her left leg over her husband's right, the figurative motif of overlapping thighs being, in the iconographical tradition of the time, an allusion to sexual intercourse. On the ground, a ribbon bearing the inscription *nec spe nec metu* (neither hope, nor fear) shows for whom the plate must have been made: Isabella d'Este, one of the greatest patrons of the Renaissance. It formed part of the great historiated faience service given by the marchesa to her daughter Eleonora.

PETRUS PAULUS, *KNOWN AS* **PETER PAUL RUBENS** (1577–1640)
Henry IV Receiving the Portrait of Marie de' Medici, 1622–1625
Oil on canvas, 12 ft. 11 in. × 9 ft. 8 in. (3.94 × 2.95 m)

This picture belongs to a cycle of paintings dedicated to the life of Marie de'Medici. Her marriage to Henry IV of France was above all motivated by political considerations and was totally unsentimental. It was her enormous dowry rather than her beauty that attracted the French monarch to the daughter of the grand duke of Tuscany. Rubens, however, here shows Henri IV in rapt admiration before an image of Marie, who at the time he had never seen. The portrait of his betrothed is presented by Hymen, god of marriage (on the left), and by Cupid, god of love (to the right). Enthroned among the clouds, Jupiter and Juno contemplate the scene. Hands entwined in a symbol of matrimonial harmony and concord, the divine couple seems to gaze down approvingly on the earthly union to come, embodying its celestial equivalent.

In point of fact, the marriage between god and goddess was hardly plain sailing; and, like the master of Olympus, Henry IV was well-known for his wandering eye. The painter here wisely lays the stress on love. The bewitched king, still in his armor—France was then at war with Savoy—has entrusted his helmet and shield to the care of some gamboling *putti.* The painting, therefore, places at its center the rejection of war, paralleling the conciliatory policy promoted by Marie de'Medici herself. Thus is marriage a cog in the world of diplomacy and politics.

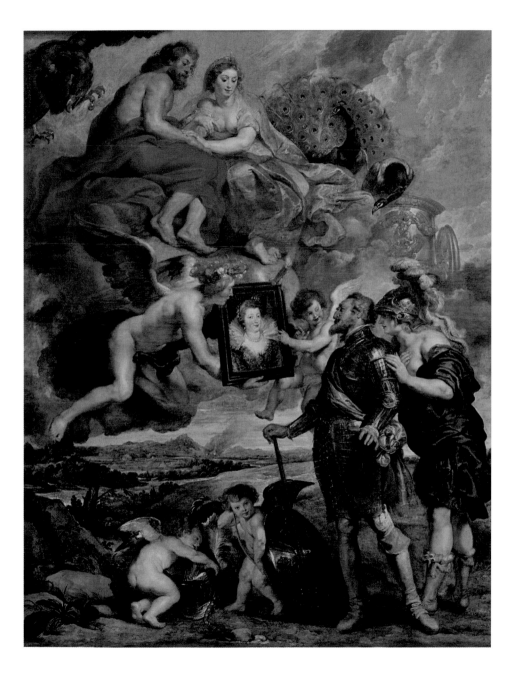

THOMAS GAINSBOROUGH (1727–1788)
Conversation in a Park, c. 1746–1747
Oil on canvas, 28 ¾ in. × 26 ¾ in. (73 × 68 cm)

An animated young man is seated on a bench next to an elegant lady, whom he is busy courting. Waving his arm, he tries in vain to attract her attention, but his companion appears absorbed by something else entirely. This double portrait most probably shows the artist and his wife Margaret, who had recently married. There is no physical contact, no tenderness, no emotion suggested in the painting, which clearly indicates the relationship was characterized by a certain distance. In all probability, the young woman's dowry, rather than any personal considerations, had been instrumental in the marriage.

The picture belongs to the typically eighteenth-century English genre of the "conversation piece" in which figures were represented more naturally than in the conventional pose of a traditional portrait. The painter's talent for landscape comes over in the charming wooded backdrop framing the couple. Perhaps such lush nature is a symbol of hope for the relationship's future fertility, while the ancient ruins might stand for the temple of Hymen, goddess of marriage.

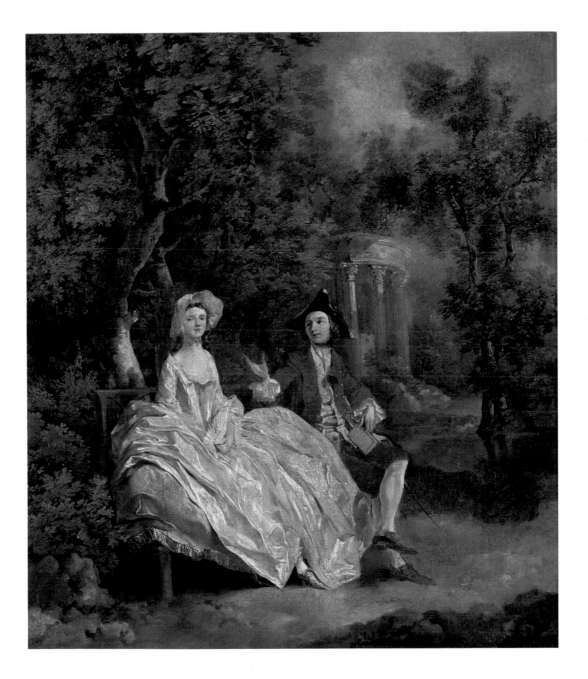

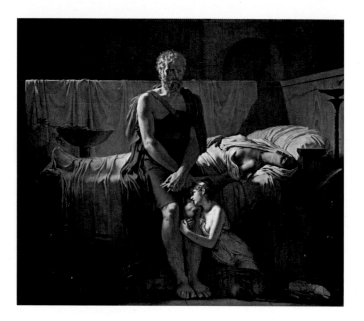

PIERRE-NARCISSE GUÉRIN (1774–1833)
The Return of Marcus Sextus, 1799
Oil on canvas, 7 ft. 1 ½ in. × 8 ft. (2.17 × 2.43 m)

This picture was the pictorial event of the Paris Salon of 1799. Guérin sets before us a gloomy episode: Marcus Sextus, banished by the dictator Sulla during the civil wars of the Roman Republic, is shown at the very moment when, returning home following the fall of his persecutor, he finds his wife dead and his family decimated. Recoiling from his beloved's rigid corpse, he clasps her fingers in his. The scene is built on a simple geometrical composition: the horizontal of the corpse and the vertical of the soldier form a cross, the preeminent symbol of suffering (Christ's Cross), chosen here to express the tragedy of bereavement. The intense chiaroscuro creates a powerful contrast that both underlines the modeling of the facial expressions and brings out the drama of the composition. This terrific piece of stagecraft was greeted with rapture by the public.

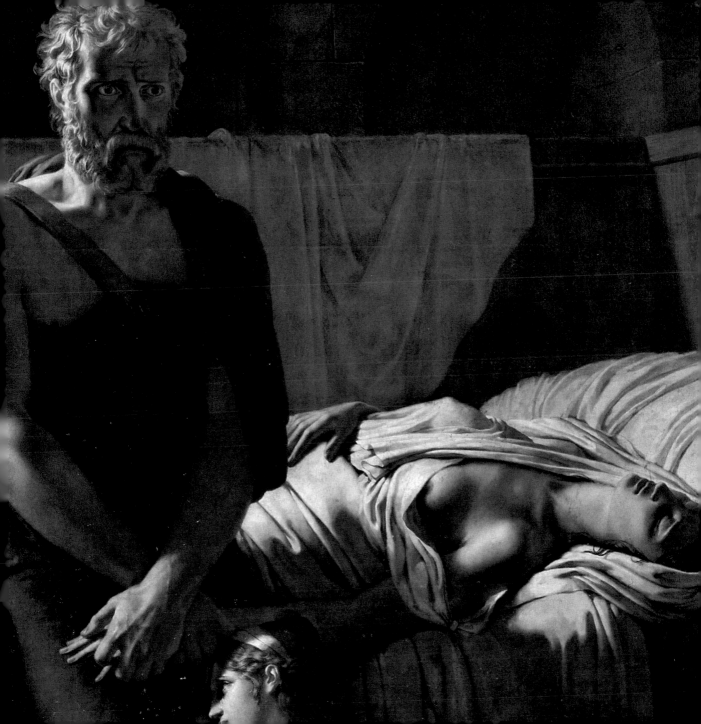

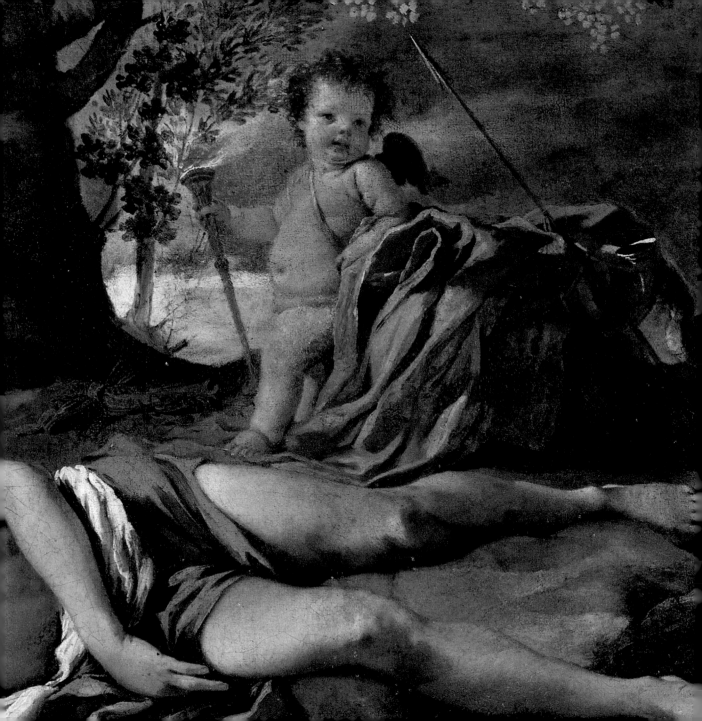

NICOLAS POUSSIN (1594–1665)
Echo and Narcissus, c. 1630
Oil on canvas, 29 × 39 in. (74 × 100 cm)

In this picture, Poussin tackles the theme of unrequited love as told in Ovid's *Metamorphoses*. Condemned to repeat only the last few words of whoever speaks to her, the poor nymph Echo has fallen in love with the handsome Narcissus. The unresponsive youth repels her advances and, in despair, the girl pines away, soon becoming no more than a voice, an echo in the mountains. Here, she is shown dissolving into the rock.

But Narcissus's indifference was not to remain unpunished: glimpsing his reflection while leaning over the water's edge, he falls in love with his own image. Unable to attain the object of his adoration, he too wastes away and is transformed into the flower that bears his name.

The painter has placed a few narcissi next to the youth's languishing body, which occupies about half the painting. His youthful beauty perhaps evokes the homosexual feelings implicit in the myth. Inspired by a depiction of the dead Christ, this nude evokes both tragic lament and pathos. The landscape, tinged blood-red, adds further to the work's sense of tragedy. Standing between the couple as they expire, Cupid, holding a lighted torch, makes plain the misfortunes that threaten all those afflicted by love.

ANNE-LOUIS GIRODET DE ROUSSY-TRIOSON (1767–1824)
Endymion, Moon Effect, also known as *The Sleep of Endymion*, 1791
Oil on canvas, 6 ft. 6 in. × 8 ft. 6 ¾ in. (1.98 × 2.61 m)

A shepherd of staggering beauty, Endymion was condemned to sleep for thirty years. The goddess Diana (the Moon), not usually prone to desire, was so entranced by the beauty of the young mortal that each night she would come to gaze at him. In this painting, Endymion is depicted naked and overcome by slumber, lounging beneath a plane-tree. Zephyr (the wind) draws aside the branches and Diana, in the form of a moonbeam, caresses the face and chest of the object of her adoration, enwrapping his peerless physique in an unearthly glow.

Following his self-proclaimed desire to do something new, Girodet's painting is most idiosyncratic. Endymion's graceful nudity evinces something at once sensual and chilly, while his body, although as smooth as a marble statue, languishes like a woman abandoning herself to the pleasures of the flesh. The effect of the light creates a feeling of unreality and strangeness that foreshadows Romantic art.

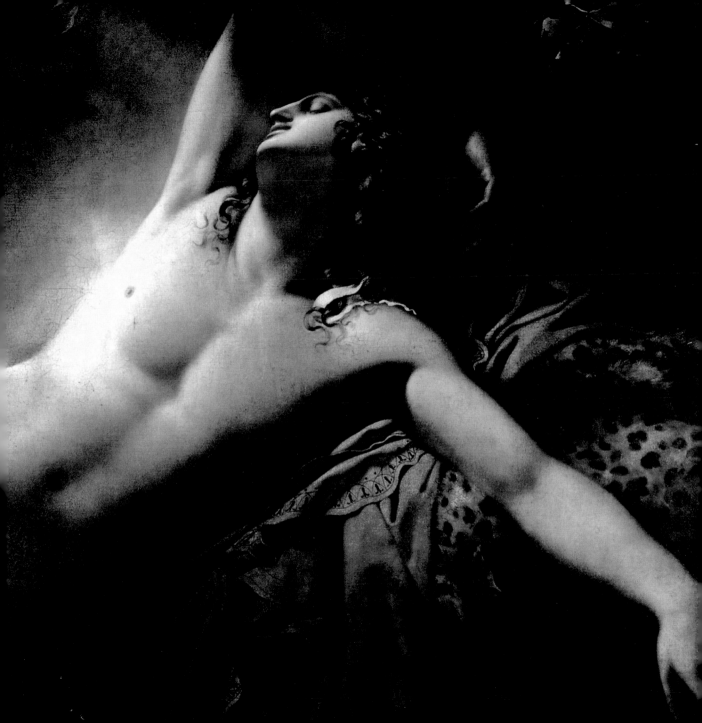

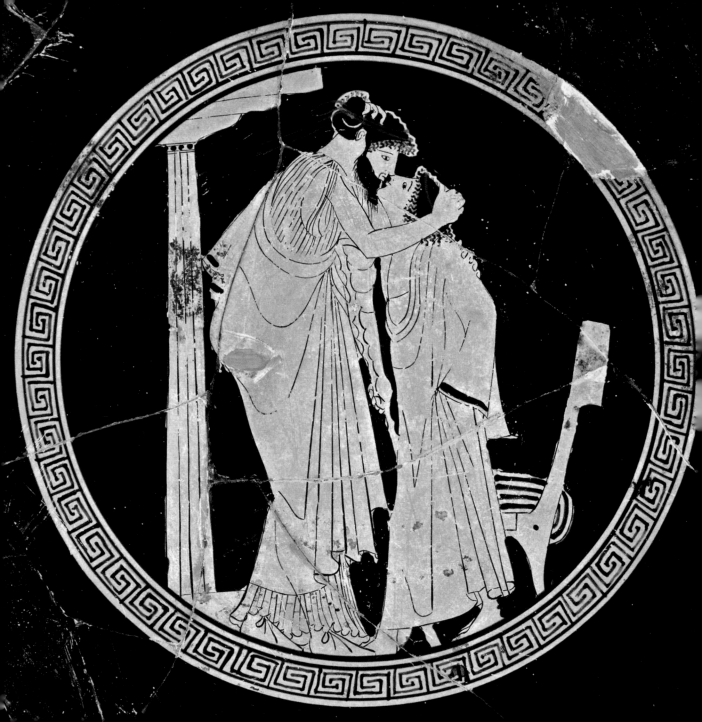

1. THE BRISEIS PAINTER
Man with Boy, Athens, c. 480 BCE
Red-figure cup, 2 ⅞ × 13 ½ in. (7.4 × 34.4 cm); d. 10 ⅜ in. (26.4 cm)

2. MUHAMMAD QASIM
Portrait of Shah 'Abbas I embracing one of his Pages, Isfahan, Iran, 1627
Ink, gouache, gold, and silver on paper, 10 × 5 ⅞ in. (25.5 × 15 cm)

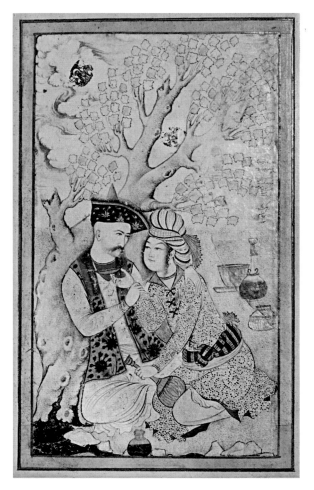

1. This red-figure cup from the Classical period shows a male couple embracing. In ancient Greek society, there was nothing taboo about male homosexuality, especially when it took the form of the initiation between an adult male, the *eraste*, and an adolescent boy, the *eromene*.

In such a situation, the elder of the two was committed to protecting and respecting his young companion, for whom he was to act as a role model. The bearded man here caresses his young protégé tenderly, a representation that testifies to actual practice as much as to erotic fantasy. Other items of the same type, frequent at this period, are far more explicit in their depiction of sexual union.

2. A young page offers wine to Shah 'Abbas I, a reforming monarch who occupied the throne of Iran from 1588 to 1627. Clearly, the relationship between the two figures is affectionate as well as sensual, although the manner in which the somewhat effeminate page holds the bottle between his legs is, at the very least, suggestive.

This scene, in a delicate and original style, recalls a feast thrown by the shah. In the upper part of the drawing, a poem declares: "Let life bestow upon you whatever you desire from the three lips: those of the lover, those of the river, and those of the cup."

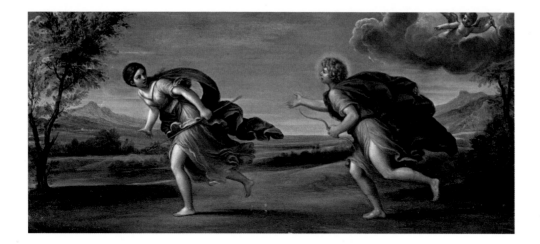

FRANCESCO ALBANI (1578–1660)
Apollo and Daphne, c. 1620–1625
Oil on copper, 6 ⅞ in. × 14 in. (17.5 × 35.5 cm)

To punish Apollo for laughing at his weapons, Cupid fired a golden arrow at him to make him fall in love. Meanwhile, he hit Daphne with a dart made of lead, thereby making her immune to all seduction (as recounted in Ovid's *Metamorphoses*). Pursued by Apollo, Daphne begged her father to help her to escape the god's ardor by changing her into a bay tree. This is the moment generally treated by artists, but Albani instead portrays the god running after the nymph, with the format of this little copper panel lending itself well to a scene of pursuit. From high on a cloud, Cupid, visibly amused, peers down on the results of his mischief. This myth of unrequited passion was sometimes given a moral interpretation, with Daphne the personification of chastity and Apollo that of desire. Albani's version of the scene is especially noteworthy for its delicate handling, the virtuoso miniaturist technique, and the quicksilver palette.

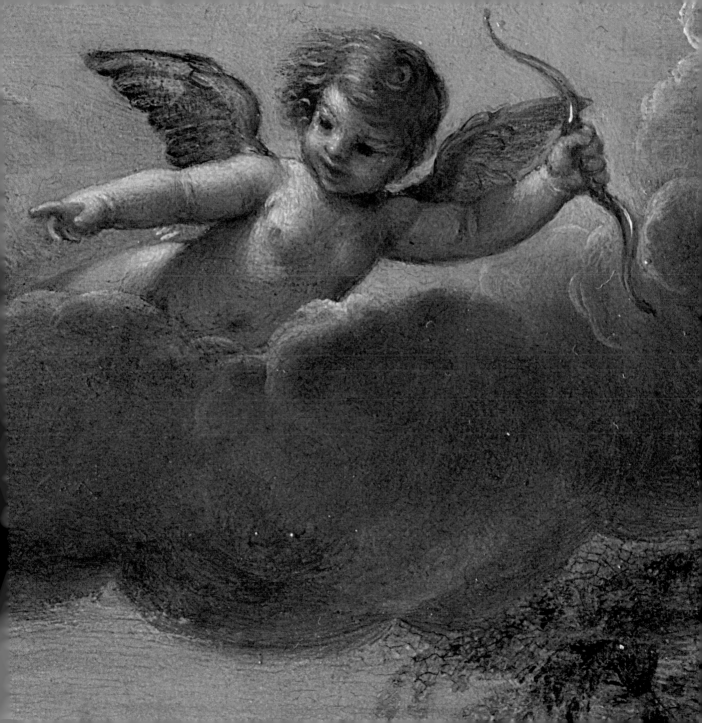

ANONYMOUS
Venus and her Six Legendary Lovers
or *Venus Triumphant*, confinement tray,
Florence c. 1400
Tempera on wood, d. 20 in. (51 cm)

This object is a *desco da parto*, also known as a birth tray, or confinement tray, a present traditionally given by a husband to his wife in celebration of her giving birth. As was customary during the Renaissance, the painter here illustrates the power of love through symbols.

Identifiable from the inscriptions on their garments, six famous lovers from mythology, the Bible, and medieval romance—Achilles, Tristan, Lancelot, Samson, Paris, and Troilus—kneel together in a luxuriant garden and gaze up at the Venus floating above them in a mandorla similar to the one that surrounds a Christ triumphant or the Virgin at her Assumption. The black-winged goddess is clearly victorious over allcomers: the rays emanating from her vagina strike the knights on the face, while the fruits covering the greenery stand for the generative and procreative force of the deity.

In the context in which it was made and presented, such an image is obviously meant to exalt the reproductive capacities of womanhood, but this "christianized" Venus also celebrates a love in which the spiritual and the sensual are united.

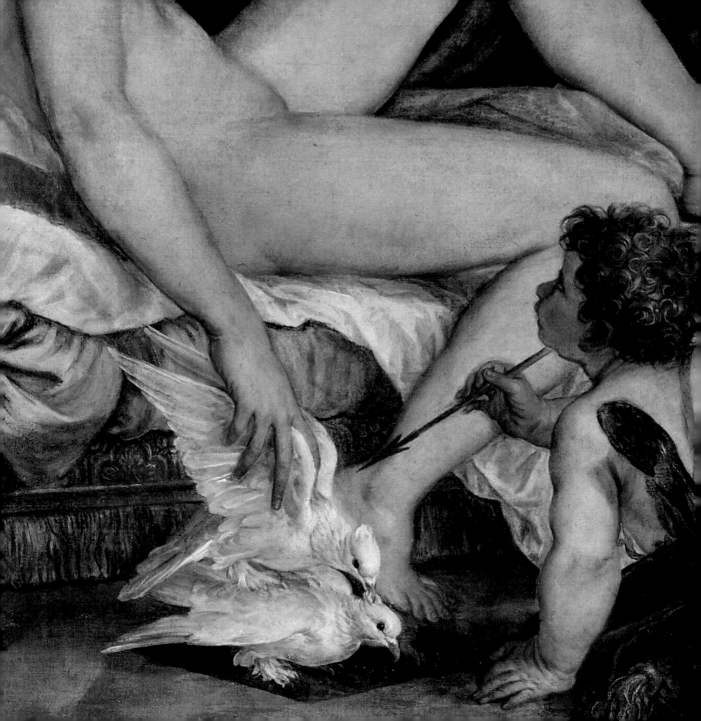

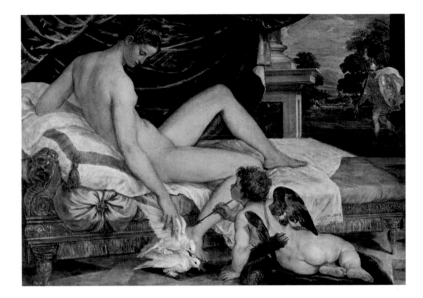

LAMBERT SUSTRIS (c. 1515/20–after 1568)
Venus and Cupid, c. 1560
Oil on canvas, 4 ft. 4 in. × 6 ft. (1.32 × 1.84 m)

Lying on a bed, Venus is waiting for her lover, Mars. To the right of the composition, the god of war is shown encased in armor. The northern European painter Lambert Sustris here reverts to the Venetian tradition of a female nude reclining inside or in the open air, with mythology serving as a pretext for the depiction of an idealized feminine beauty. The snow-white body of the goddess, caressing a pair of doves, stands out boldly against the red velvet that demarcates the love-nest, curtaining it off from the public sphere.

The birds shown, both messengers of love and symbols of pleasure, are frequent attributes of the goddess, and here the pair prefigures the imminent union of Venus and Mars. At the foot of the bed, we see Cupid, pointing his dart in the birds' direction and making the message still more explicit.

PIETRO DI CRISTOFORO VANNUCCI, *KNOWN AS* PERUGINO (c. 1450–1523)
The Battle between Love and Chastity, 1505
Oil on canvas, 5 ft. 3 in. × 6 ft. 3 in. (1.60 × 1.91 m)

Isabella d'Este, Marchesa of Mantua, had her *studiolo* (small private study) decorated with a cycle of mythological and allegorical paintings extolling spiritual love and its triumph over the carnal variety. Some of these pictures refer directly to her marriage to Gian Francesco Gonzaga.

Perugino's complex cycle of paintings was devised in collaboration with the marchesa, with advice from scholars in her entourage. It illustrates the theme of the battle between Chastity and Lust, embodied, in the center of the composition, by Diana, the divine huntress, on the left, and Venus, goddess of love, on the right. In the background various scenes of passion and abduction take place, among them Apollo pursuing Daphne (see, on this theme, page 26).

Chastity and her companions seem to have the upper hand, as the virgin goddess Minerva (in red armor next to Diana) is getting the better of Cupid. A shield decorated with fleurs de lis and eagle heads—an allusion to the armorial bearings of Isabella d'Este—is affixed to an olive tree in which perches an owl (both attributes of Minerva). The position of the shield indicates that Isabella is on the side of celestial and sublimated love. Through this complex interplay of symbols the painting celebrates the virtues both of the patron and of her married life.

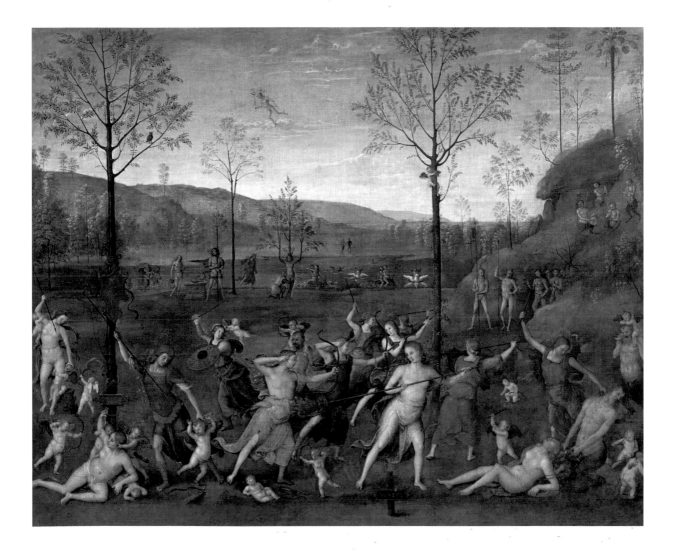

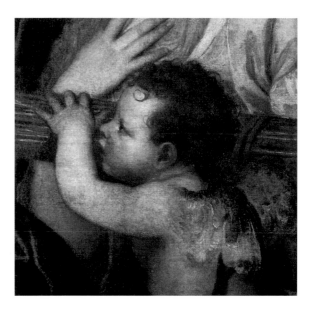

TIZIANO VECELLI, *CALLED* TITIAN (c. 1490–1576)
Allegory of Married Life, also known as *The Allegory of the Marquis d'Avalos*, c. 1530-1532
Oil on canvas, 4 ft. × 3 ft. 6 in. (1.21 × 1.07 m)

In many respects this allegory, commissioned from Titian for private use, remains enigmatic. The picture shows a man and a woman in the guise of Mars and Venus, with Cupid carrying a bundle of wood over his shoulder in allusion to the couple's union. Crowned with myrtle—a plant that symbolizes enduring love—the girl with her hand on her breast probably stands for marital fidelity. Gazing upwards, the second girl could be interpreted as the personification of hope. The basket of roses she lifts up to heaven might refer either to the pleasures of love or perhaps to a future offspring.

All these elements suggest the celebration of a wedding. However, the man in armor seems downcast, and his partner seems pensive. The crystal globe lying on the thighs of the young woman is likely to be a symbol of the fragility of human life, and perhaps alludes to the death of the young woman herself, or to the death of her young child or baby. These interpretations remain open and testify to the complexity of a work carried out at a period when love was often evoked by a whole catalogue of symbolic references.

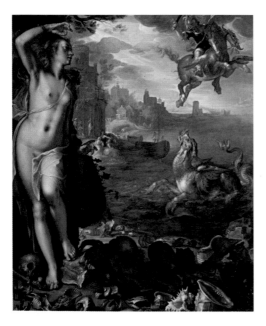

JOACHIM WTEWAEL (1556–1638)
Perseus Rescuing Andromeda, 1611
Oil on canvas, 5 ft. 10 in. × 4 ft. 11 in. (1.80 × 1.50 m)

In this painting, the artist blatantly employs the story of Perseus and Andromeda from Ovid's *Metamorphoses* as a pretext for a display of female flesh. Perseus, mounted on Pegasus, his winged steed, joins battle with the sea monster that has captured the beautiful Andromeda, shown manacled to a rock. The girl's index finger points to her panic-stricken parents just visible on the shore. Here eroticism rubs shoulders with death: Andromeda's body is exposed as much for the benefit of the beholder as for Perseus, yet she is in danger of being devoured.

A detail in the image expresses the same idea: at Andromeda's feet lies a skull, an allusion to the transitory nature of life, together with a shell whose form echoes that of female genitalia.

As a reward for his valor, Perseus received Andromeda as his wife; their matrimonial union is foreshadowed by the gesture she makes with her right hand. With its sinuous forms, wealth of references, highly charged composition, and acidulous palette, this elegant and refined painting is characteristic of Mannerism, of which Wtewael was one of the foremost northern European exponents.

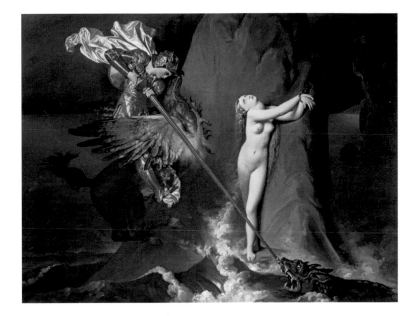

JEAN-AUGUSTE DOMINIQUE INGRES (1780–1867)
Roger Delivering Angelica, 1819
Oil on canvas, 4 ft. 9 in. × 6 ft. 3 in. (1.47 × 1.90 m)

Inspired by Canto X of Ariosto's *Orlando Furioso* (1516), this painting is more than a mere literary illustration. Angelica, a princess of Cathay (China), was abducted by the Ebudians to be sacrificed to a marine monster. She is shown by Ingres to be torn between hope and terror, her head thrown back and eyes rolling. Mounted on a hippogriff, the valorous knight Roger is depicted preparing to slay the fierce beast. The iconography of this picture, with its brightly illuminated female nude, has parallels with that of Perseus and Andromeda.

In this powerfully theatrical composition, the painter makes much of the contrast between the vulnerable and sensual flesh of the prisoner, whose alabaster body stands out against an inhospitable shore, and Roger's dazzling breastplate, together with the wings, talons, and feathers of his mount.

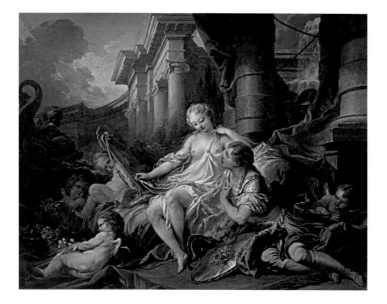

FRANÇOIS BOUCHER (1703–1770)
Rinaldo and Armida, 1734
Oil on canvas, 4 ft. 5 in. × 5 ft. 7 in. (1.35 × 1.70 m)

For the *morceau de réception* he painted to qualify for entry to the French Royal Academy of Painting and Sculpture, Boucher took as his starting point Tasso's *Gerusalemme Liberata* ("Jerusalem Delivered," 1581), a fictionalized account of the First Crusade. It relates how the knight Rinaldo, among all the crusaders, remained insensitive to the charms of the sorceress Armida. Grossly offended, she cast a love spell over him to keep him captive in her enchanted palace. In the painting, Rinaldo lies at the feet of the beauty, with Cupid pointing his fatal arrow at him. Concealing themselves behind a column, Rinaldo's companions,

Carlo and Ubaldo, observe their friend as he falls victim to the spellbinding charm of the young Saracen. Bedazzled by passion, the hero sacrifices his masculinity and divests himself of his helmet and shield.

Hand on heart, he rests, swooning in an effeminate and graceful attitude of the kind Boucher was to employ a few years later in painting Venus. Rinaldo's face is as delicate as a girl's, as if love itself turns everything upside-down. Under its influence, Rinaldo has even forfeited his identity, creating a disorder that is reflected in a topsy-turvy backdrop in which *putti,* fabrics of every description, plants, and architectural elements vie for attention.

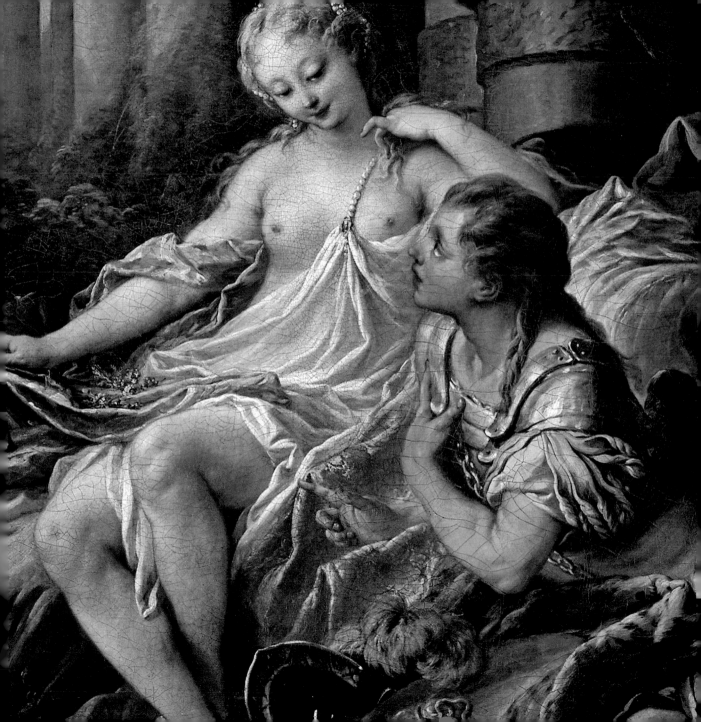

FRANÇOIS LEMOYNE (1688–1737)
Hercules and Omphale, 1724
Oil on canvas, 6 ft. × 4 ft. 10 ½ in. (1.84 × 1.49 m)

This mythological theme favors an inversion of the roles traditionally assigned to women and men in amorous relationships. Both characters indulge in a degree of cross-dressing: Hercules, the virile hero if ever there was one, has fallen for the queen of Lydia, Omphale, whose lover and slave he has become. Draped in a precious robe, distaff and spindle in hand, Hercules is reduced to spinning wool—traditionally women's work. Omphale, on the other hand, sporting her lover's lion skin, has picked up his cudgel and rubs it suggestively against her pearl-white body. Bewitched by love, the totally subjugated Hercules feasts his eyes on Omphale. The painterly treatment—in fluid and fluent brushstrokes and rich, bright hues—closely corresponds to the subject treated, since the sensuality of painting mirrors that of love. The artist's admiration for the Venetian Renaissance masters is evident in the evocative power of his palette.

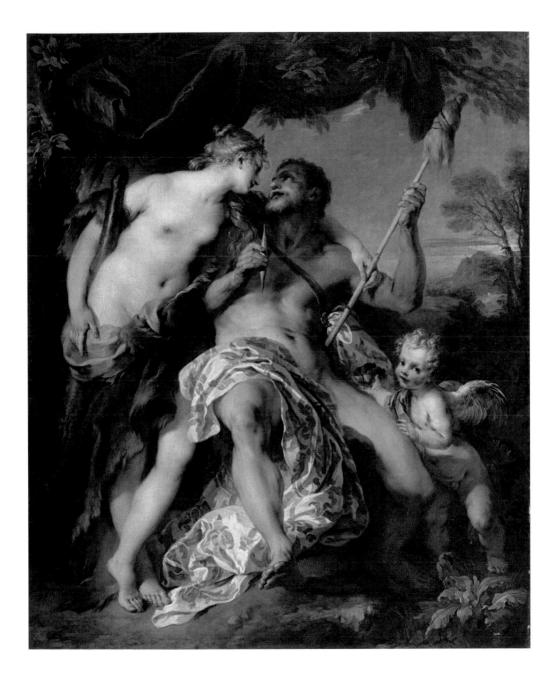

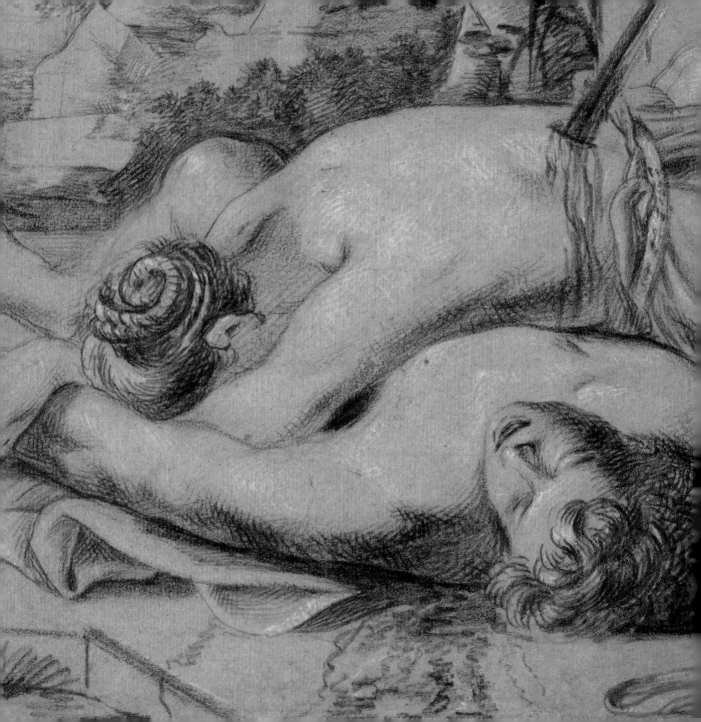

LAURENT DE LA HYRE (1606–1656)
The Death of Pyramus and Thisbe
Black chalk with white highlights on gray paper, 11 ¼ in. × 17 ⅜ in. (28.5 × 44.1 cm)

In spite of their parents' disapproval, two young Babylonians, Pyramus and Thisbe, fell head over heels in love (Ovid, *Metamorphoses*). One night, they arranged to tryst beneath a mulberry tree. Thisbe arrived first, but ran off when she saw an approaching lioness, mouth stained with the blood of a recent catch. As she escaped, she dropped a piece of cloth, which the beast began to gnaw. Pyramus then turned up. Imagining the worst upon discovering Thisbe's blood-stained veil, he killed himself. Thisbe returned to the mulberry tree, only to find the body of her lover, and committed suicide in her turn.

Artists depicting the scene have tended to show the moment Thisbe stabs herself with a sword. La Hyre's more original solution, showing one body lying across the other to convey the enduring strength of their passion, confers upon the tragic scene an especially touching intensity.

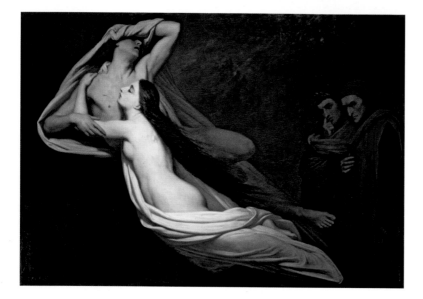

ARY SCHEFFER (1795–1858)
*The Shades of Francesca da Rimini and Paolo Malatesta
Appearing to Dante and Virgil*, 1855
Oil on canvas, 5 ft. 7 in. × 7 ft. 10 in. (1.71 × 2.39 m)

Ary Scheffer, who had been instrumental in the triumph of Romantic painting at the Salon of 1827–1828, was fond of dramatic subjects. Here, he illustrates a passage from Dante's *Divine Comedy*, Canto V, in which the poet, accompanied by Virgil, encounters the spirits of Paolo and Francesca, condemned to the torments of Hell for having yielded to the temptations of forbidden love. Francesca was killed with Paolo, her brother-in-law, when her husband surprised them together one day. The awful destiny of this couple inspired many artists, including Ingres and Delacroix, but none mixed the sensual and mystical dimensions to the same degree as Scheffer. Although the artist depicts the couple's physical bodies fused in an embrace, he nonetheless emphasizes their amorous spirits, with their weightless, luminous forms standing out from the gloom. Here, love endures beyond the earthly realm, wrapped in a fervent, eternal caress.

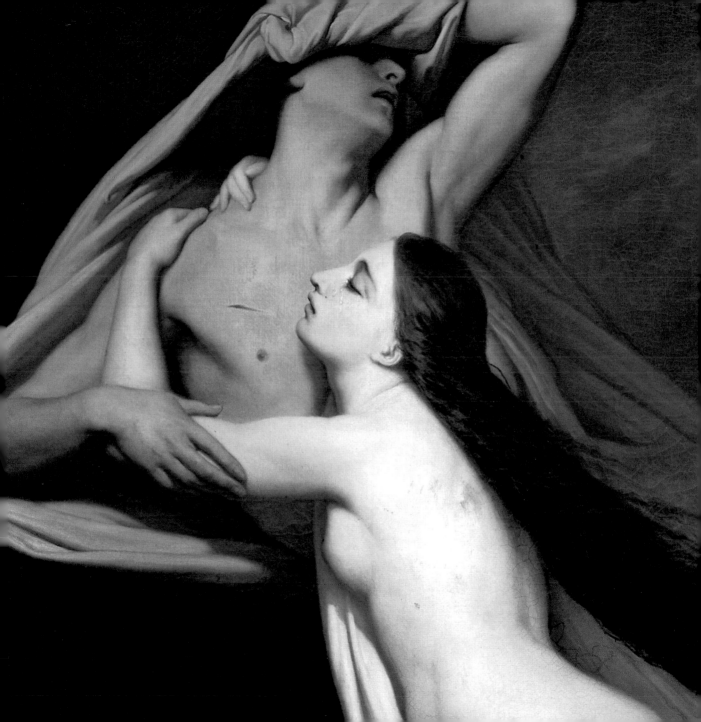

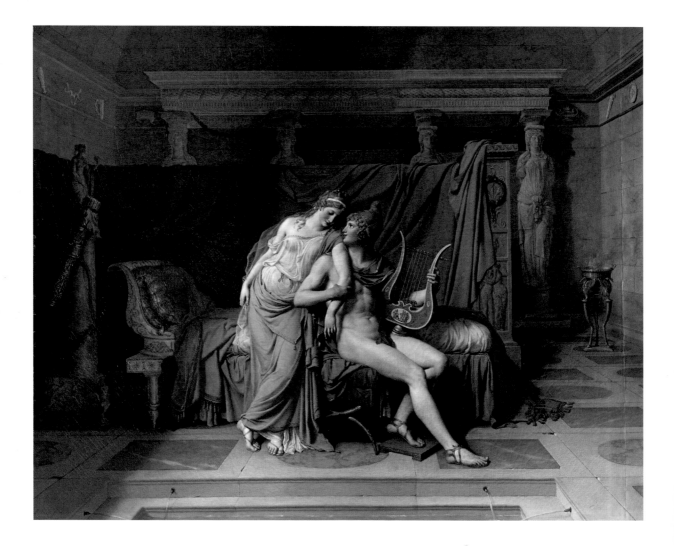

JACQUES-LOUIS DAVID (1748–1825)
Paris and Helen, 1788
Oil on canvas, 4 ft. 9 in. × 5 ft. 11 in. (1.46 × 1.81 m)

Exhibited at the 1789 Salon, this picture recalls the illicit love of Paris and Helen, wife of Menelaus, king of Sparta. The seduction of the beauty by the young Phrygian shepherd sparked the Trojan War related in *The Iliad*.

Illustrations of this erotic episode are rare; the majority of artists, such as Luca Giordano and Guido Reni, preferred to depict the moment of abduction itself. In this painting, Helen leans on Paris, with eyes lowered—betraying embarrassment or perhaps an awareness of her sin. The burning passion of the latter is betrayed by his ruddy cheeks and the expression in his eyes. In addition to the many references to

classical antiquity, the composition contains a number of allusions to love. On the left, upon a column, stands a statue of Venus, whose image reappears on the medallion decorating Paris's lyre. To the right and behind the bridal bed, a crown of myrtle, symbol of Hymen, is affixed to a screen wall. Beneath this crown a bas-relief shows Cupid and Psyche embracing. These allegorical elements all testify to the painter's erudition, and combine to create a work that is all grace and elegance; a style markedly different from the severe sobriety of the earlier *The Oath of the Horatii* (1784).

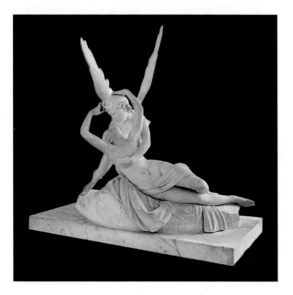

ANTONIO CANOVA (1757–1822)
Psyche Revived by Cupid's Kiss, 1787–1793
Marble, 5 ft. 1 in. × 5 ft. 6 in. (1.55 × 1.68 m); d. 3 ft. 4 in. (1.01 m)

In a story drawn from Apuleius's *Golden Ass*, a novel from the classical world, Canova depicts Cupid as he revives Psyche, delicately laying one hand against the girl's cheek and the other on her breast. Psyche, in spite of Venus's express command, had breathed in the fatal vapor of a noxious perfume and had plunged into a deep torpor. She disobeyed Venus on two occasions, and her ordeals symbolized the efforts of the spirit to transcend the body, with the young girl personifying the aspiration of the human soul to the divine.

In his treatment of the theme, Canova created a sculpture of unparalleled grace. Although the marble used is especially hard, there is no trace of heaviness in this simple, buoyant group, all curves and arabesques. Canova spent several years on this veritable tour de force, and left a large number of studies illustrating its development.

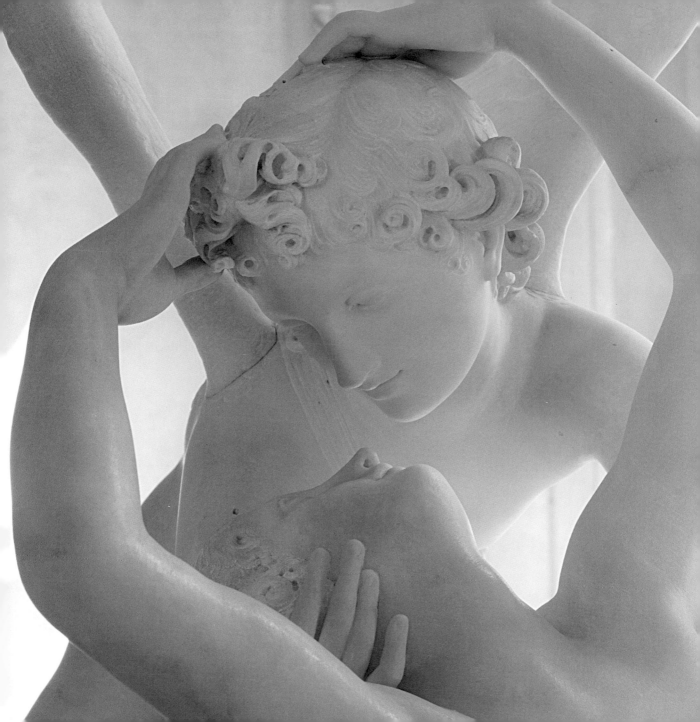

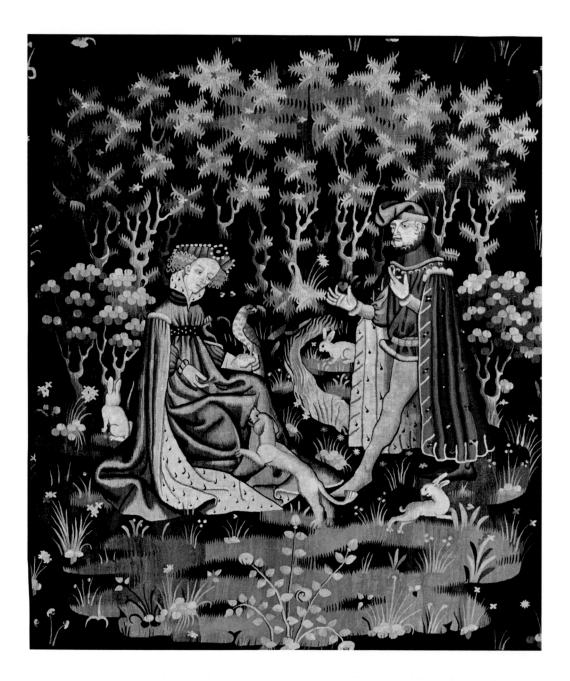

ANONYMOUS
The Gift of the Heart
Paris?, 1400–1410
Wool and silk, 8 ft. 1 in. × 6 ft. 10 in. (2.47 × 2.09 m)

This tapestry illustrates one of the best-known themes of courtly love, the offering of the heart. In a flowery garden, a richly dressed woman sits holding a falcon, the symbol of love, in one hand, and in the other a flower, an allusion to her virginity. Her beau advances towards her, enveloped in a large, ermine-lined cloak in the fashion of the fifteenth century, and clutching a small heart, a metaphor for his declaration of love. Both figures are clearly members of the aristocracy.

The animals in the garden, such as the barking dog and the rabbits, were traditional symbols used to represent love, this time in its physical sense.

ANONYMOUS
Pair of mirror covers
Courtly scenes, Paris, c. 1310–1320
Elephant ivory, d. 4 ⅜ in. (11 cm)

These two lids form part of one of the rare complete mirror covers intact today. On each of them, four "chambers" of greenery, separated by trees and branches, contain four fluently and elegantly drawn couples. The graceful figures disport themselves tenderly; one strokes the chin of another—a gesture which, in the Middle Ages, stood for affection—while others sit together on a bench, one holding a falcon and the other a small dog. Elsewhere again, the young lady crowns her suitor as he kneels or else he is shown presenting her with a bouquet. This delicate object, a veritable catalogue of love scenes, thus combines various symbols of courtly love: gloves, flower garland (known as a *chapel de fleurs*), falcon, little dog, crown, and so on.

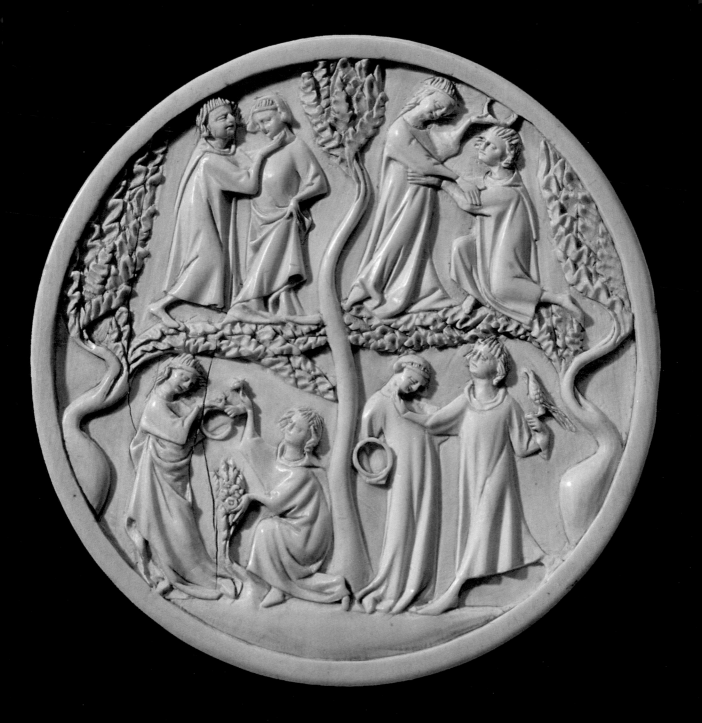

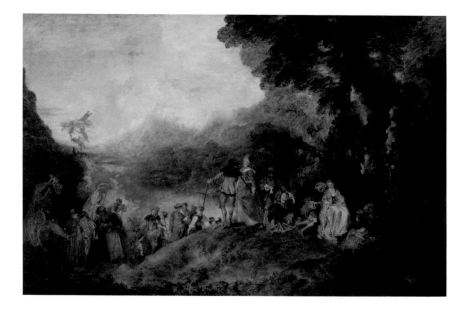

JEAN-ANTOINE WATTEAU (1684–1721)
Pilgrimage to Cythera, 1717
Oil on canvas, 4 ft. 3 in. × 6 ft. 4 in. (1.29 × 1.94 m)

For his *morceau de réception* to qualify for the French Royal Academy of Painting and Sculpture, Watteau invented the genre known as the *fête galante*, which entails a group of lovers disporting themselves in a park or wood. Here he portrays an idyllic world in which the pastoral is influenced by the theater. This famous piece evokes the journey of the lovers to the Isle of Cythera, the island of love devoted to Venus, whose statue on the right of the painting is draped in rose blossoms, her symbol. In an enchanting, hazy atmosphere, the young people are shown indulging in the delights of seduction: strolling, arms about one another's waists, exchanging sweet nothings. In the air above, several *putti* exalt the pleasures of love.

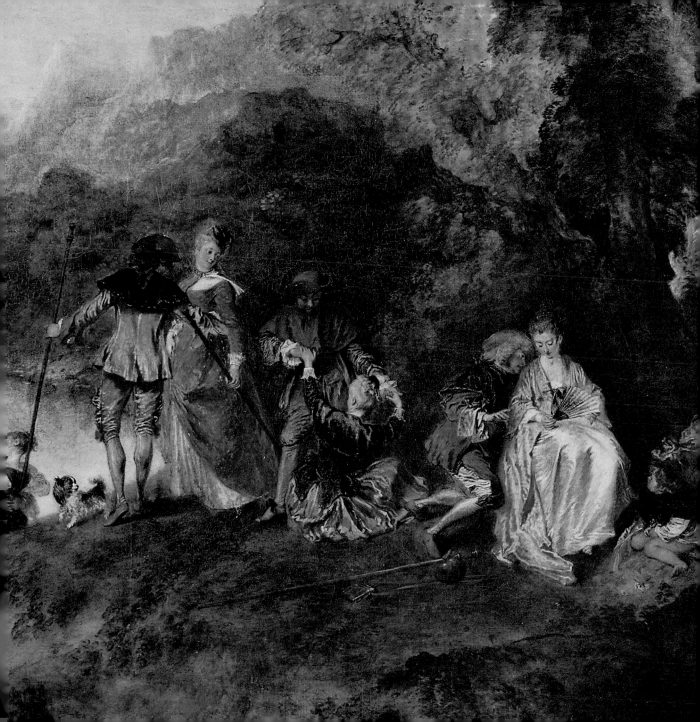

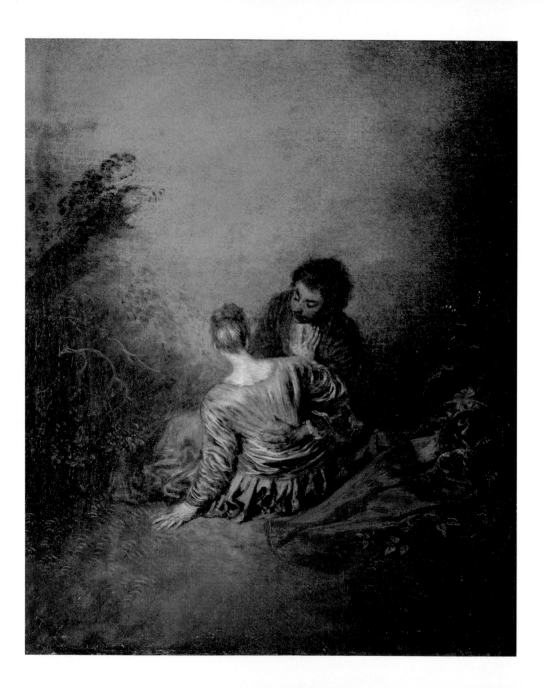

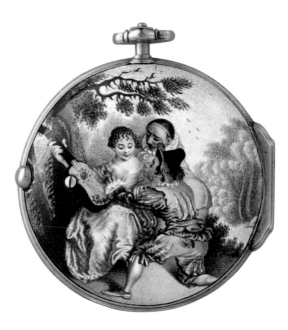

1. **JEAN-ANTOINE WATTEAU** (1684–1721)
The Faux-Pas, c. 1716–1717
Oil on canvas, 15 ¾ × 12 ¼ in. (40 × 31 cm)

2. **JULIEN LE ROY** (1686–1759)
Le Conteur, ("Storyteller") after Antoine Watteau, c. 1730–1760
Round watch in gold, gilded bronze, and enamel,
d. 1 ¾ in. (4.6 cm); th. ⅞ in. (2.3 cm)

1. In *The Faux-Pas*, small talk makes way for frank desire. The vulnerability of the young woman is betrayed by the way she shrinks back in the face of the insistent and somewhat aggressive attitude of her companion, uncertain which way to turn. Fear is countered by ardor, reflected in the sanguine complexion of the man, which is in contrast to the girl's pallor. The picture's small format reinforces the oppressive character of a scene in which virtue is shown under siege. The position of the young woman, seen from behind, allows us both to identify with her, conveying the intensity of her discomfort in the presence of the man's intrusion, and places us in the role of voyeur.

Such ambiguity is far from rare in Watteau, a past master at suggestion and double entendre. The painter often hints at more than he shows, suggesting more than he actually depicts. The gestures of the figures are frequently evasive or incomplete, their backs turned, faces hidden, or eyes lowered. In this painting, it is the conclusion of the encounter that is uncertain; the outcome is left up to the beholder.

2. During the eighteenth century, refined and precious accessories were appreciated no less than love scenes, as this watch, inspired by an engraving by Watteau, proves. Dressed like an actor from the *commedia dell'arte*, the *Conteur* (or storyteller) is courting a young belle. Behind them is a glimpse of the ever-pining lover, Pierrot.

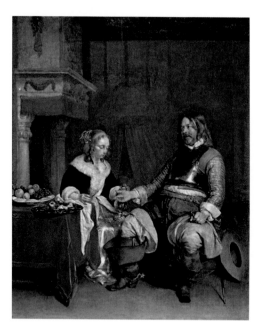

GERARD TER BORCH, *CALLED* THE YOUNGER (1608–1681)
The Military Gallant or *Young Woman being Offered Money by a Man*, c. 1660–1663
Oil on canvas, 26 ¾ in. × 21 ½ in. (68 × 55 cm)

Although this soldier in cavalry boots is obviously off duty, he is nonetheless in a hurry. Firmly planted on his chair, legs apart, he has thrown off his hat and imperiously interrupts the courteous gesture of a young woman about to serve him some wine. Holding out his money, the cavalryman, seeming to tremble with desire and anticipation, stares fixedly at the woman's face. Disarmed by such forwardness, she lowers her eyes, looking somewhat forlorn. She might seem modest enough were it not for the coin in the soldier's hand and the rich fur décolleté that is just revealing enough to leave little doubt about the true nature of her profession. This reading is supported by the half-drawn curtain at the rear, an allusion to the next phase of the transaction, which takes place in the bedchamber concealed behind it.

Representations of venal love are not rare in Dutch painting of the time, but Gerard ter Borch has managed to portray this commonplace scene with humanity and delicacy.

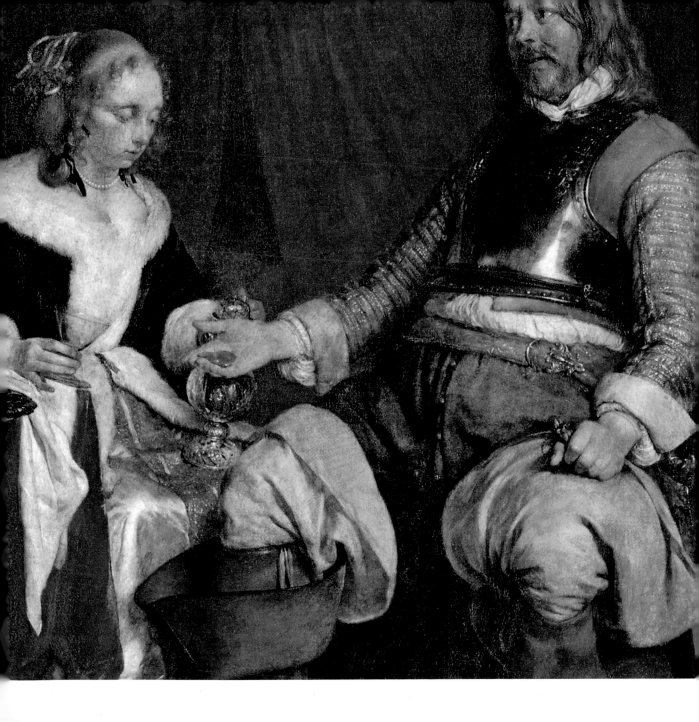

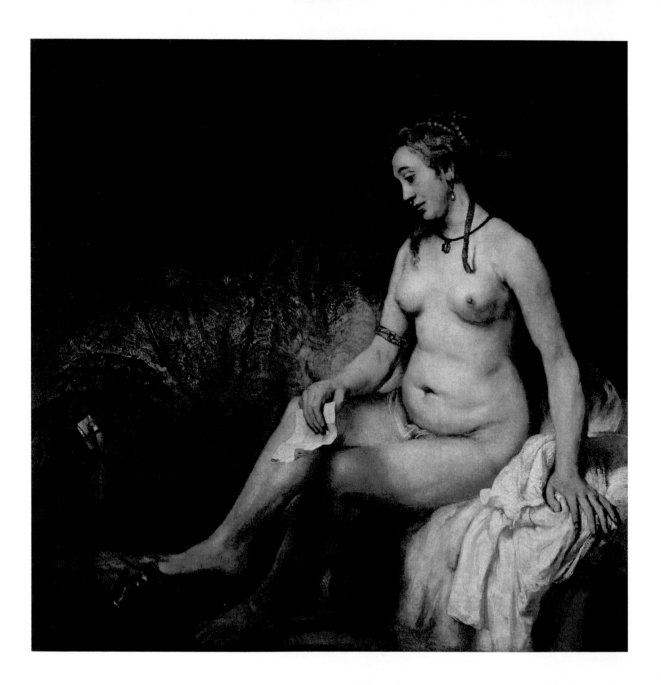

REMBRANDT HARMENSZ. VAN RIJN (1606–1669)
Bathsheba at her Bath with David's Letter, 1654
Oil on canvas, 56 × 56 in. (1.42 × 1.42 m)

Bathsheba, wife of the general Uriah, has set David's pulses racing and the king sends for her by letter. Rembrandt portrays the distress of the young woman after she receives the imperious missive. The hushed gravity of the scene prefigures its unhappy outcome: after seducing Bathsheba, David will have her husband killed, and the first-born child of their illicit union will also perish. The looming tragedy is implicit in the picture.

Emerging from the half-light, the splendid physique of Bathsheba expresses, in its fragile nudity, all the vulnerability of offended virtue.

The painter has sought to render such intense emotions truthfully, yet, if the young woman sits pensively enough, her body oozes sensuality; a reflection, perhaps, of the fact that Rembrandt used as his model his partner at the time, Hendrickje Stoffels.

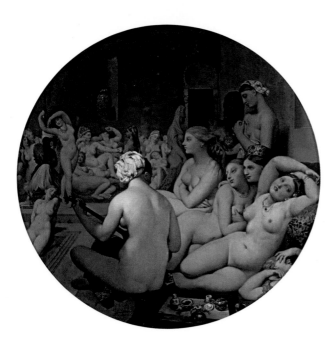

JEAN-AUGUSTE-DOMINIQUE INGRES (1780–1867)
The Turkish Bath, 1862
Oil on canvas, 3 ft. 6 ½ in. × 3 ft. 7 in. (1.08 × 1.10 m)

Ingres was to paint this, his most erotic picture, at the age of eighty-two. His harem is crowded with twenty-five figures representing a variety of anatomies and attitudes, in a visual catalogue of poses and forms. One woman dances, another reclines on a sofa, elsewhere women do their hair or apply perfume, take coffee or caress a companion. The bodies are often contorted, even deformed. Harmony reigns, however, because the nude figures seem almost to interlock, their gestures forming a continuously shifting chain of circles. The arabesques and womanly curves so created complement and are in turn complemented by the circular format of the canvas.

This paean to nudity takes place in a space that is simultaneously deep and enclosed, an intimate space belonging exclusively to women. Voyeuristic viewers of both sexes can nevertheless revel in this sensuous vision of flesh and invitation to things of love.

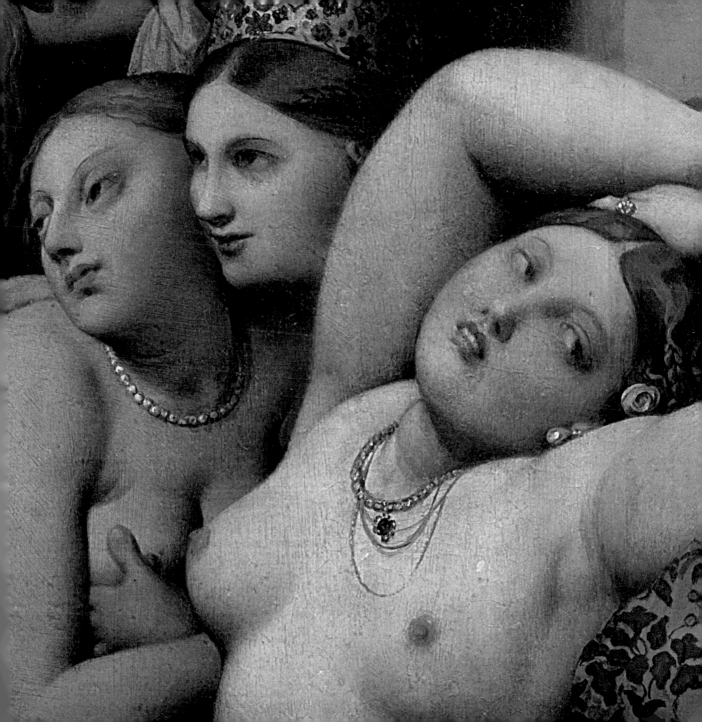

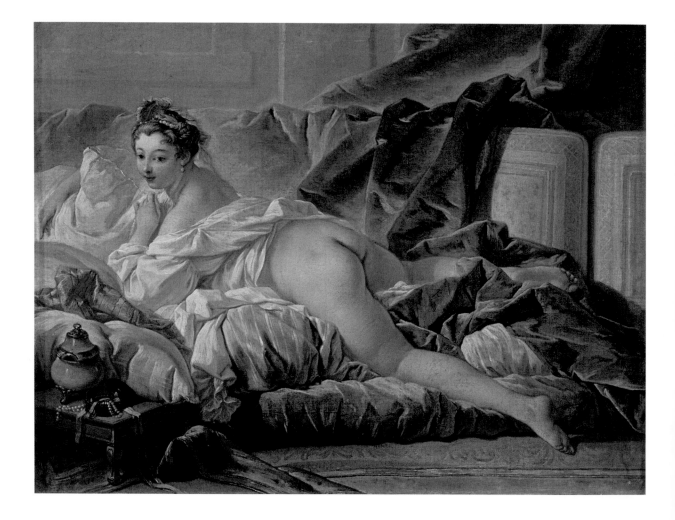

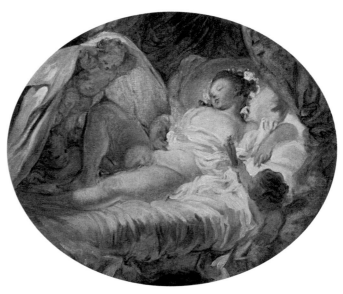

1. FRANÇOIS BOUCHER (1703–1770)
The Odalisque, c. 1745
Oil on canvas, 20 ½ × 25 in. (53 × 64 cm)

2. JEAN-HONORÉ FRAGONARD (1732–1806)
Le Feu aux poudres, also known as *The Powder Keg,* c. 1763–1764
Oil on canvas, 14 ½ × 17 ¾ in. (37 × 45 cm)

1. Unusually for the period, Boucher did not have to resort to a mythological or allegorical subject to depict the charms of the female body. Here he focuses boldly on the attractions of a naked woman, represented in the full bloom of her sensuality. The abundance of crumpled fabrics echoes the availability and surrender of the figure. Her clearly individualized facial features are, however, in the manner of a portrait. The critic Diderot thought he could recognize Boucher's wife and castigated the painter for his flippancy.

Still, if an allegory might have deflected criticism of this nature, it wouldn't necessarily result in a less daring picture.

2. The composition and title of the *Feu aux poudres* (evoking the image of "lighting the blue touch-paper") are evident pointers to some kind of allegory, but the pretext is as if nullified by the impact of Fragonard's pictorial invention.

The painter here unveils a male fantasy of observing unnoticed a woman immersed in an erotic dream. The *putti* are as if participants in a libertine afterpiece, likely to fire the imagination of the most jaded viewer; they look youthful but have in truth lost their innocence long ago. Fragonard mixes daring with a suggestion of sadism, since a *putto* can be seen placing a lighted torch between the bare legs of the sleeping girl.

CLAUDE MICHEL, *CALLED* CLODION (1738–1814)
Leda and the Swan, c. 1782
Tonnerre stone, bas-relief, 3 ft. 4 in. × 3 ft. 7 in. (1.02 × 1.09 m); d. 10 ⅝ in. (27 cm)

Clodion has depicted an episode borrowed once more from Ovid's *Metamorphoses*. Here the nymph Leda, accosted by Jupiter in the shape of a swan, strives, with an elegant movement, to pull back from the assault; the sculptor has added a jeering Cupid, hidden behind a tree. The scene belongs to a series of reliefs originally decorating the bathroom in the Paris townhouse of the Baron de Besenval, which had been conceived along the lines of a nymphaeum.

Each sculpture in the series represents a different facet of the beauty of the female body. Leda's pose is lifted directly from a picture by Correggio, now in the Kunsthistorisches Museum, Vienna. This quotation from a Renaissance master, together with the sensual grace of the pose of the nymph, must have delighted the patron, the Baron de Besenval, whose philandering reputation was no less well known than his great passion for the fine arts.

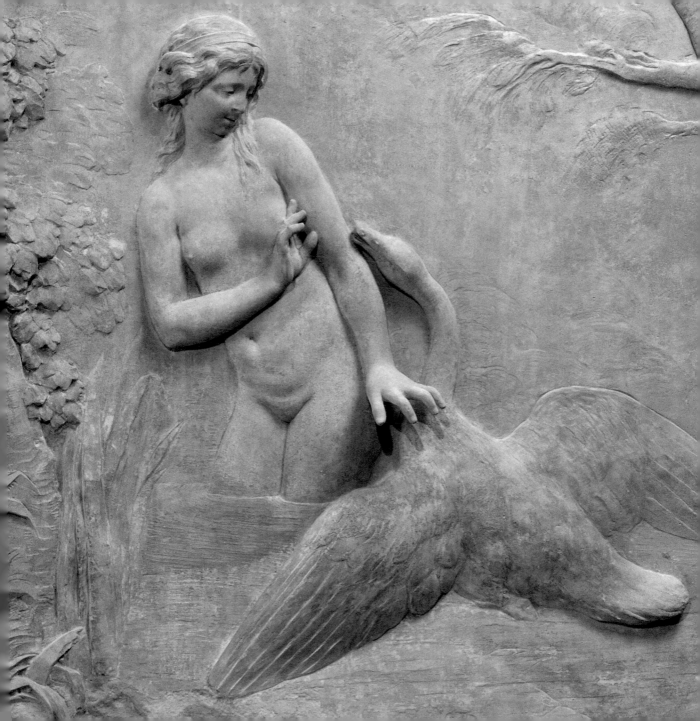

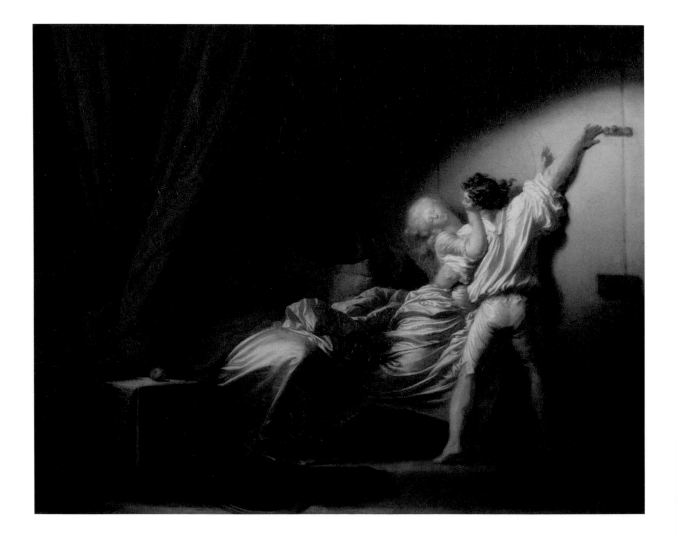

JEAN-HONORÉ FRAGONARD (1732–1806)
The Bolt, c. 1777
Oil on canvas, 29 × 37 in. (74 × 94 cm)

In a closeted chamber, a young man, determined to overcome his lover's resistance, has slammed shut the bolt. Reeling from this outburst of desire, the heroine appears to have lost control of her emotions. The left section of the picture is completely dominated by a vast bed, on which the disorder of the bedding alludes to physical paroxysm, while the upside-down jug symbolizes the loss of virginity.

The painting teems with implicit references to a sex act that is either imminent or perhaps already past: one of the corners of the bed reproduces the graceful swelling of the woman's knee, the pillows plot the curve of a breast from the side, while the half-open crimson hangings perhaps hint at the female pudendum.

Although characteristic of Fragonard's penchant for light and erotic subjects, the piece is not entirely devoid of moral connotations. An oblique line connects the bolt to the lovers' faces and to an apple on the bedside table, in an obvious allusion to original sin. The pendant to this work was *Adoration of the Shepherds* (1775), also in the Louvre. The combination of these two pictures allows Fragonard to expatiate on the power of love, first in its sexual aspect—less to encourage as to denounce it, perhaps—and secondly in its spiritual dimension, as a model of moral development.

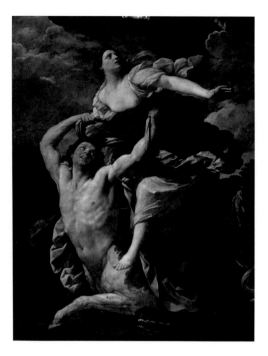

GUIDO RENI (1575–1642)
Dejanira Abducted by the Centaur Nessus, 1617–1621
Oil on canvas, 7 ft. 10 in. × 6 ft. 4 in. (2.39 × 1.93 m)

This enormous mythological picture also takes its cue from Ovid's *Metamorphoses*. It depicts the episode in which Hercules entrusts his wife Dejanira to the centaur Nessus, who has offered to take her across a river. However, overcome by desire, Nessus suddenly makes a bid to carry off the princess. Reni portrays the centaur's face flushed with ardor as he grabs the terrified Dejanira. On the bank, Hercules is on the point of firing a poisoned arrow at the miscreant.

This work belongs to a series of four paintings devoted to the story of Hercules. In them, Guido Reni draws inspiration from ancient statuary for his treatment of the masculine nude. It is hard to say what is the more impressive, the artist's mastery of form or the unbridled passion of the centaur.

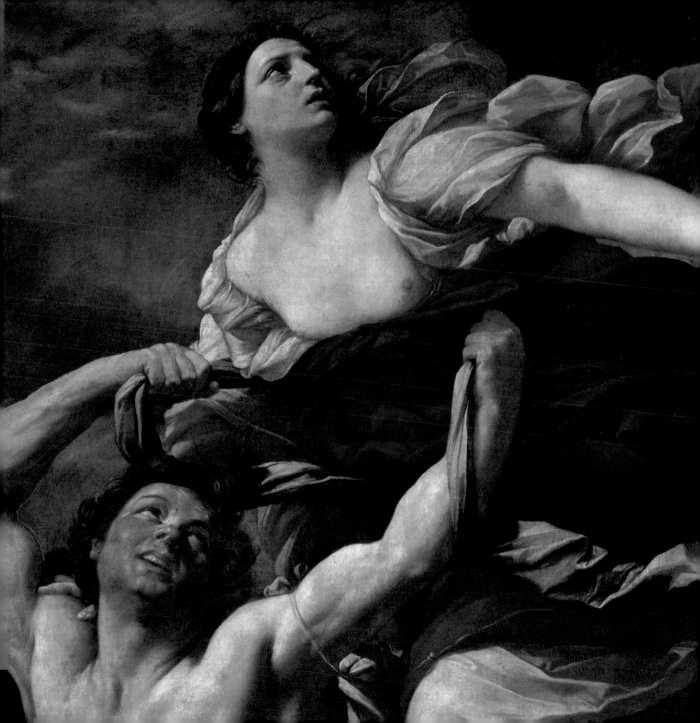

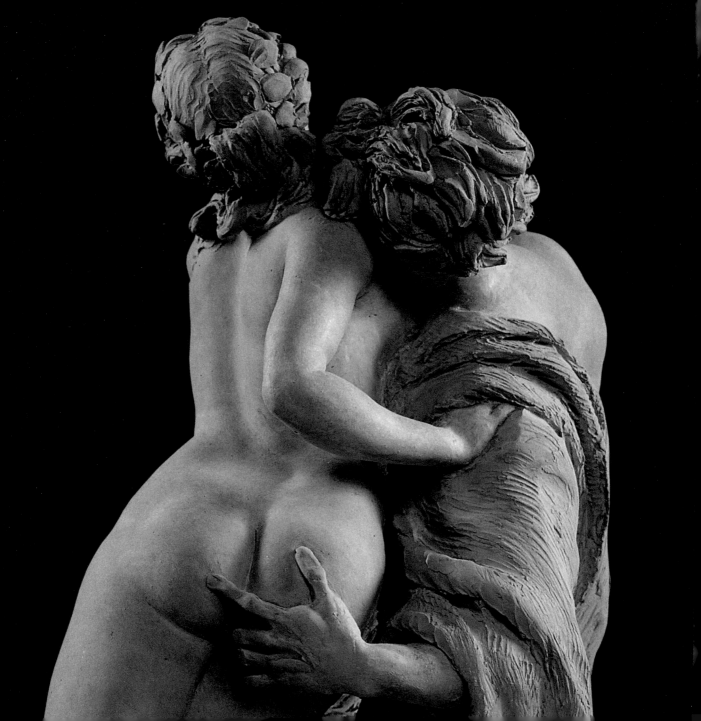

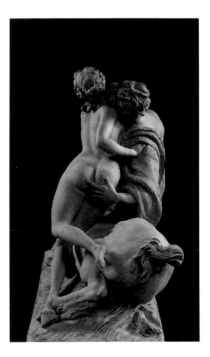

JOHAN TOBIAS SERGEL (1740–1814)
Centaur Grabbing a Bacchante, group, c. 1775–1778
Terracotta, 14 ⅜ × 15 ½ in. (36.5 × 39.5 cm); d. 6 ¾ in. (17.5 cm)

In this sculpture, the relationship between formal treatment and subject is particularly striking. The centaur seems to have been hewn from a chunk of immovable matter, in the face of which the bacchante is defenseless. The rough cloth of the centaur's garment is in striking contrast to the graceful forms and smooth skin of the girl. Snatching up the bacchante in a powerful grip, the centaur kisses the back of her neck, his great hands pressing into her flesh. The woman's surrender to the creature's bestial energy is conveyed by the apparent instability of the composition, as illustrated by the pair's dramatic leaning to one side.

This piece is often photographed from the rear, most probably because here the erotic charge of the abduction is at its most forthright.

LIST OF ILLUSTRATIONS

P. 26
Francesco Albani (1578–1660)
Apollo and Daphne, c. 1620–1625
Oil on copper, 6 ⅞ in. × 14 in.
(17.5 × 35.5 cm)
Inv. 18
Department of Paintings

P. 28
Anonymous
Venus and her Six Legendary Lovers
or *Venus Triumphant*, confinement tray,
Florence c. 1400
Tempera on wood, d. 20 in. (51 cm)
Inv. R.F. 2089
Department of Decorative Arts

P. 31
Lambert Sustris (c. 1515/20–after 1568)
Venus and Cupid, c. 1560
Oil on canvas, 4 ft. 4 in. × 6 ft.
(1.32 × 1.84 m)
Inv. 1978
Department of Paintings

P. 33
**Pietro di Cristoforo Vannucci,
known as Perugino** (c. 1450–1523)
The Battle between Love and Chastity, 1505
Oil on canvas, 5 ft. 3 in. × 6 ft. 3 in.
(1.60 × 1.91 m)
Inv. 722
Department of Paintings

P. 34
Tiziano Vecelli, *called* Titian
(c. 1490–1576)
Allegory of Married Life, also known
as *The Allegory of the Marquis d'Avalos*,
c. 1530-1532
Oil on canvas, 4 ft. × 3ft. 6 in.
(1.21 × 1.07 m)
Inv. 754
Department of Paintings

P. 36
Joachim Wtewael (1556–1638)
Perseus Rescuing Andromeda, 1611
Oil on canvas, 5 ft. 10 in. × 4 ft. 11 in.
(1.80 × 1.50 m)
Inv. R.F. 1982-51
Department of Paintings

P. 39
Jean-Auguste Dominique Ingres
(1780–1867)
Roger Delivering Angelica, 1819
Oil on canvas, 4 ft. 9 in. × 6 ft. 3 in.
(1.47 × 1.90 m)
Inv. 5419
Department of Paintings

P. 40
François Boucher (1703–1770)
Rinaldo and Armida, 1734
Oil on canvas, 4 ft. 5 in. × 5 ft. 7 in.
(1.35 × 1.70 m)
Inv. 2720
Department of Paintings

P. 43
François Lemoyne (1688–1737)
Hercules and Omphale, 1724
Oil on canvas, 6 ft. × 4 ft. 10 ½ in.
(1.84 × 1.49 m)
Inv. M.I. 1086
Department of Paintings

P. 45
Laurent de La Hyre (1606–1656)
The Death of Pyramus and Thisbe
Black chalk with white highlights on gray
paper, 11 ¼ in. × 17 ⅜ in. (28.5 × 44.1 cm)
Department of Prints and Drawings

P. 46
Ary Scheffer (1795–1858)
*The Shades of Francesca da Rimini
and Paolo Malatesta Appearing to Dante
and Virgil*, 1855
Oil on canvas, 5 ft. 7 in. × 7 ft. 10 in.
(1.71 × 2.39 m)
Inv. R.F. 1217
Department of Paintings

P. 48
Jacques-Louis David (1748–1825)
Paris and Helen, 1788
Oil on canvas, 4 ft. 9 in. × 5 ft. 11 in.
(1.46 × 1.81 m)
Inv. 3696
Department of Paintings

P. 50

Antonio Canova (1757–1822)
Psyche Revived by Cupid's Kiss, 1787–1793
Marble, 5 ft. 1 in. × 5 ft. 6 in.
(1.55 × 1.68 m); d. 3 ft. 4 in. (1.01 m)
Inv. M.R. 1777
Department of Sculpture

P. 52

Anonymous
The Gift of the Heart
Paris?, 1400–1410
Wool and silk, 8 ft. 1 in. × 6 ft. 10 in.
(2.47 × 2.09 m)
Inv. OA 3131
Department of Decorative Arts

P. 54

Anonymous
Pair of mirror covers
Courtly scenes, Paris, c. 1310–1320
Elephant ivory, d. 4 ⅜ in. (11 cm)
Inv. MRR 197
Department of Decorative Arts

P. 56

Jean-Antoine Watteau (1684–1721)
Pilgrimage to Cythera, 1717
Oil on canvas, 4 ft. 3 in. × 6 ft. 4 in.
(1.29 × 1.94 m)
Inv. 8525
Department of Paintings

P. 58

Jean-Antoine Watteau (1684–1721)
The Faux-Pas, c. 1716–1717
Oil on canvas, 15 ¾ × 12 ¼ in.
(40 × 31 cm)
Inv. M.I. 1127
Department of Paintings

P. 59

Julien Le Roy (1686–1759)
"Le Conteur," after Antoine Watteau,
c. 1730–1760
Round watch in gold, gilded bronze,
and enamel, d. 1 ¾ in. (4.6 cm);
th. ⅞ in. (2.3 cm)
Inv. OA 8340
Department of Decorative Arts

P. 60

Gerard ter Borch *called* **the Younger**
(1608–1681)
The Military Gallant or *Young Woman
being Offered Money by a Man*,
c. 1660–1663
Oil on canvas, 26 ¾ in. × 21 ½ in.
(68 × 55 cm)
Inv. 1899
Department of Paintings

P. 62

Rembrandt Harmensz. Van Rijn
(1606–1669)
Bathsheba at her Bath with David's Letter,
1654
Oil on canvas, 56 × 56 in. (1.42 × 1.42 m)
Inv. M.I. 957
Department of Paintings

P. 64

Jean-Auguste-Dominique Ingres
(1780–1867)
The Turkish Bath, 1862
Oil on canvas, 3 ft. 6 ½ in. × 3 ft. 7 in.
(1.08 × 1.10 m)
Inv. R.F. 1934
Department of Paintings

P. 66

François Boucher (1703–1770)
The Odalisque, 1745?
Oil on canvas, 20 ¾ × 25 in. (53 × 64 cm)
Inv. R.F. 2140
Department of Paintings

P. 67

Jean-Honoré Fragonard (1732–1806)
Le Feu aux poudres, also known as
The Powder Keg, c. 1763-1764
Oil on canvas, 14 ½ × 17 ¾ in.
(37 × 45 cm)
Inv. R.F. 1942-21
Department of Paintings

P. 68

Claude Michel, *called* **Clodion**
(1738–1814)
Leda and the Swan, c. 1782
Tonnerre stone bas-relief,
3 ft. 4 in. × 3 ft. 7 in. (1.02 × 1.09 m);
d. 10 ⅝ in. (27 cm)
Inv. R.F. 4103
Department of Sculpture

P. 70
Jean-Honoré Fragonard (1732–1806)
The Bolt, c. 1777
Oil on canvas, 29 × 37 in. (74 × 94 cm)
Inv. R.F. 1974-2
Department of Paintings

P. 72
Guido Reni (1575–1642)
Dejanira Abducted by the Centaur Nessus,
1617–1621
Oil on canvas, 7 ft. 10 in. × 6 ft. 4 in.
(2.39 × 1.93 m)
Inv. 537
Department of Paintings

P. 75
Johan Tobias Sergel (1740–1814)
Centaur Grabbing a Bacchante, group,
c. 1775–1778
Terracotta, 14 ⅜ × 15 ½ in.
(36.5 × 39.5 cm); d. 6 ¾ in. (17.5 cm)
Inv. R.F. 4632
Department of Paintings

IN THE SAME SERIES

Cats in the Louvre
Dogs in the Louvre
Jewels in the Louvre